COCKTAILS

AMY SACCO

© 2006 Assouline Publishing
601 West 26th Street, 18th floor
New York, NY 10001, USA
Tel.: 212 989-6810 Fax: 212 647-0005
www.assouline.com

Color separation by Luc Alexis Chasleries
Printed by Grafiche Milani (Italy)

ISBN: 2 84323 747 5

COCKTAILS

AMY SACCO

ASSOULINE

Whether it's a happy-hour martini, a Pimm's Cup at Ascot, or a vodka shot at a big Russian wedding on Brighton Beach, Brooklyn, a cocktail in hand means that something's being celebrated. Of course, there hardly needs to be an occasion for popping the Cristal cork—other than, say, nightfall and the sudden appearance of a beautiful woman. Sometimes it's the cocktail itself, that icy tonic for the soul or the libido, that is being celebrated. And that, more or less, is what I've been doing for a living ever since I opened Lot 61 in the desolate, westernmost corner of Chelsea nine years ago.

As any socialite or starlet will tell you, that was the dawn of the cocktail craze in New York City. Before then, there wasn't even such a thing as a Cosmopolitan, the pink potion that Carrie Bradshaw brought to parties across America. Bars at the time were stuck on traditional 1950s staples—Sidecars, Harvey

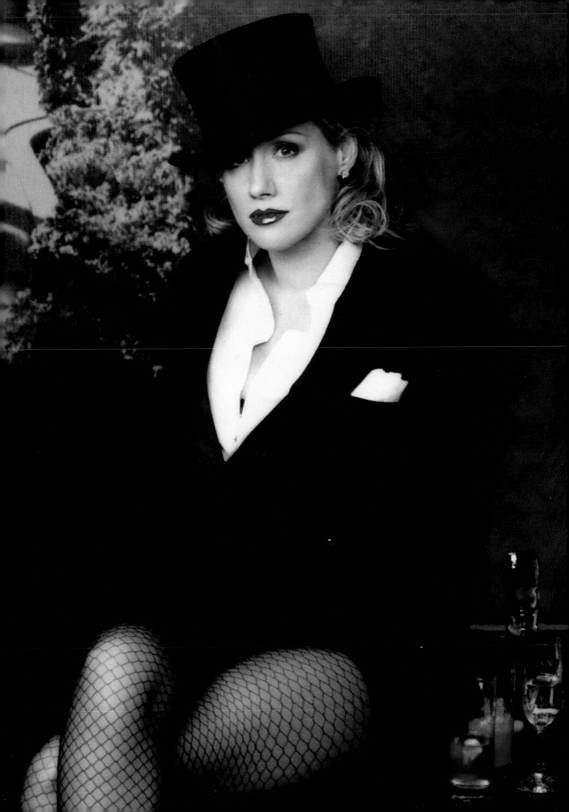

Wallbangers, White Russians—and you could still count the number of vodka brands on a single hand. But the very best part of the past, I felt, was missing: the smoky glamour of white, dinner jacket-filled boîtes like the Stork Club and El Morocco, where high society mixed with writers, movie stars, and models, and where burly but dignified bartenders knew how to mix six hundred things and asked after your wife while they polished the glasses.

because I grew up in a large family, with seven brothers and sisters, I never had anything other than a social life—a crowd to contend with or to cavort with. Our house in New Jersey was like a twenty-four-hour diner, always in full swing, with cold drinks and delicious nibbles for everybody who walked through the door. But my parents never drank, and perhaps that's why the illicit glamour of the cocktail captured my fascination. As a child of the 1980s, I was, naturally, fixated on the 1970s, but thanks to Nick and Nora Charles and *The Thin Man* movies, it wasn't long before I discovered that other great decade of decadence, the 1940s. That's when America, freed from Prohibition, kicked up its heels again. I love the moment in *The Thin Man* when Nick, played by William Powell, instructs a bartender: "Always have rhythm in your shaking. A Manhattan you always shake to fox-trot time, a Bronx to two-step time, a dry martini you always shake to waltz time."

But my cinematic touchstones are pretty inclusive, running the gamut from Louise Brooks to Lindsay Lohan, with particular

props to the cocktail-swilling likes of James Bond, Holly Golightly, and just about any playboy played by Cary Grant. I love *The Party* and *The Night of the Iguana*—movies full of glass-clinking chemistry and smartly dressed, late-night carousing. And yet the forbidden danger of the speakeasy has never quite left my mind as a party thrower: back doors, sliding peepholes, bathtub gin, the password to get into the boom-boom room.

That pleasure-at-all-costs style (this time with the blessing of the law!) is what I aimed to bring to the landscape of New York nightlife when I opened my first club a decade ago. But my background was in restaurants. I had worked in some of the finest dining rooms in the city, including Bouley and Jean-Georges, and it was the spirit of chef Jean-Georges Vongerichten's kitchen experiments in particular—infusing, steeping, muddling, and macerating—that I wanted to bring to the bar at Lot 61. We spiked simple syrups with ginger, we poured fresh fruit purees into shakers, and by opening night we had sixty-one signature martinis, the most popular of which were the watermelon, a favorite summer elixir for mini-skirted goodtime girls, and the Valentino, a chic, red, champagne-filled affair.

Of course, I wasn't the first person who wanted to have fun in West Chelsea; transsexual streetwalkers and platform-shoed club kids had tapped into the neighborhood's allure long before I did. But the area was changing, with art galleries moving in and developers eyeing derelict warehouses, and there wasn't yet a glamour destination where a girl could get out of her chauffeur-driven car, set her Manolos

on the crooked pavement, and still feel as comfortable as she did on East Sixty-third Street. That place became Lot 61, an homage to the endless possibilities of the evening: dancing until dawn, hopping on somebody's jet, cutting a deal, falling in love, or merely succumbing to a moment's desire. The drinks were named accordingly: Snowball, Porcelain Kitten, White Tiger, to cite just a few. They were drinks for the person you wanted to be, not necessarily the person you were. I know there's veritas in vino, but there's also magic: people become terribly gorgeous, wonderfully clever, thoroughly seductive. I've seen my fair share of naughtiness, but I'm proud to say that what happened at Lot 61 stayed at Lot 61.

The gorgeous life continues to be on display—at least I hope it is—at my second New York nightclub, Bungalow 8. This Malibu-inspired nocturnal cavern serves whimsical and often tropical drinks like the Mustique Mule, a riff on the vodka and ginger beer classic, and the Musha Kay, which you need a password to order. By the time Bungalow came along, I was two generations away from the drink list at Lot 61: when everybody got into martinis, I moved to champagne cocktails, and when people got into champagne, I moved into mojitos.

for the last few years I've practically lived at Bungalow 8. I became its Rick, from *Casablanca*, or, as Sean Penn once called me, its Kitty from *Gunsmoke*. I started naming drinks after our regulars and then began tweaking classic drinks with herbs and spices. The club's popularity with New York's fashion set inspired drinks such as the Brazilian Casting

Couch and the Emergen-C Martini, a vitamin-rich jolt for those revelers who still hoped to make it through fashion week.

at Bette, my new restaurant, I've returned to the 1940s, and in particular, the elegant, post-Depression 1940s of steamer trunks and Cunard cruise ships. (We even serve Baked Alaska.) We've also tried to resurrect some of the old-school showmanship of the bartender: the pithy humor, the long, elaborate pour. But the drinks are pre-Prohibition in spirit. There's a Gin Fizz made with raw egg, just as it should be, but updated with rhubarb, and there's a Sparkling Communard, our bubbly take on a drink popular with Communists in Lyons a hundred years ago. Of course, in this temperate age, I've discovered drinks for people who don't drink, too—such as tasty infused soda waters.

Truly delicious cocktails shouldn't be as hard to come by as bootlegged gin. The recipes in this book require a bit more care than a scotch and soda, but they're eminently doable, and the rewards are great. Make these at home and enjoy them with friends on nights when you don't feel like braving the throngs, the bouncers, and the movie stars dancing on tabletops. There's more than one way to celebrate, after all.

Amy Sacco,
April 2006

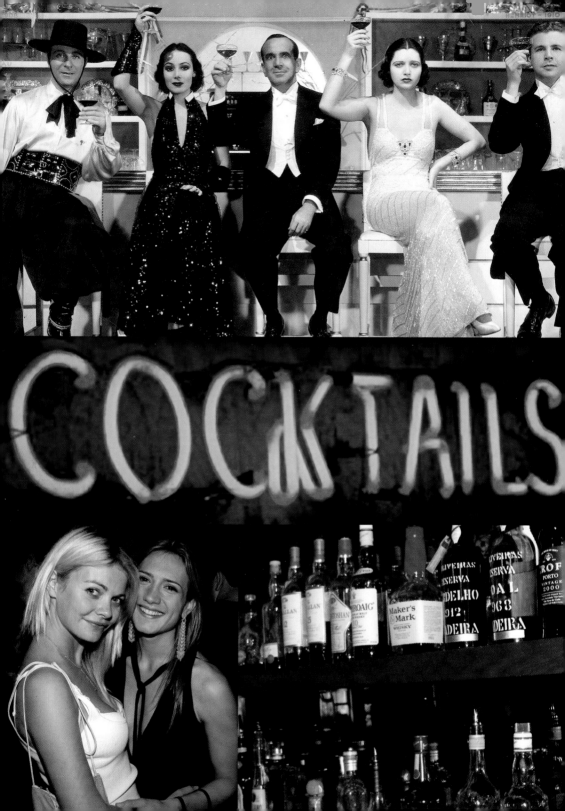

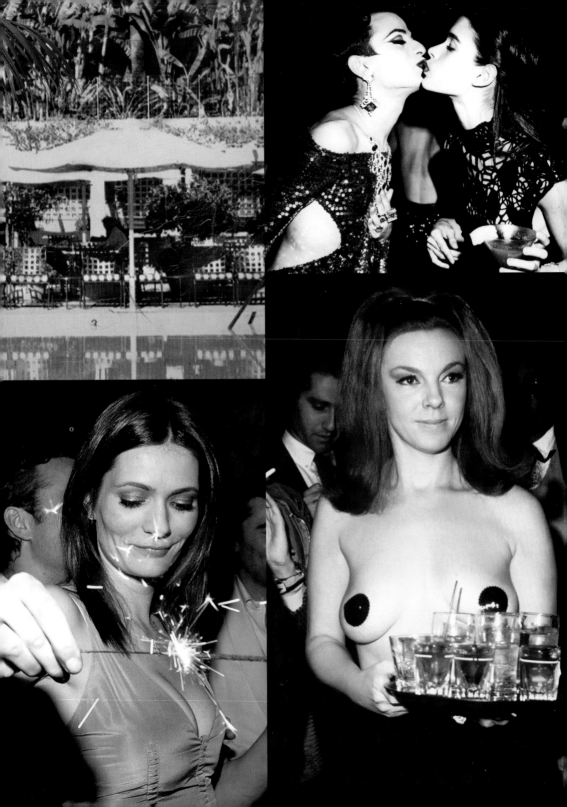

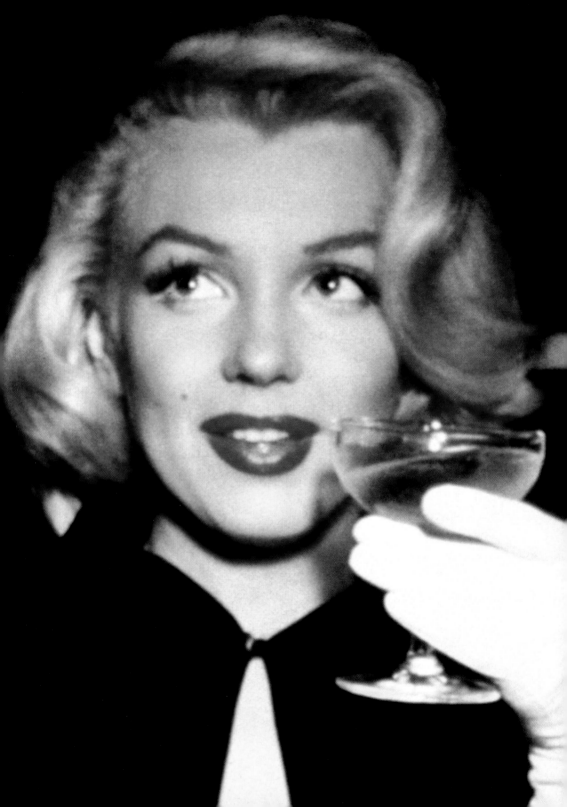

Saccotini

2 ½ oz Patron Silver
1 ½ oz plum wine
1 oz lime juice
2 tablespoons of
white sugar

MIX INGREDIENTS OVER ICE.
SHAKE AND STRAIN INTO A
CHILLED MARTINI GLASS. ADD
LIME WEDGE.

"Drink to me..."

—Pablo Picasso's
last words

Eve's Plum

1 ½ oz plum puree
½ oz plum wine
dry white wine

MIX PUREE AND PLUM WINE OVER
ICE. POUR INTO A WINE GLASS. TOP
WITH DRY. WHITE WINE (SANCERRE
WORKS WELL) AND A SPLASH OF
CLUB SODA. GARNISH WITH ROUNDS
OF PLUMS.

Bardot Martini

1 ½ oz Grey Goose vodka
¾ oz Chambord
2–3 muddled blackberries
2 tablespoons of sugar

MIX INGREDIENTS OVER ICE. SHAKE
AND STRAIN INTO A CHILLED, SUGAR–
RIMMED MARTINI GLASS. TOP OFF
WITH CHAMPAGNE.

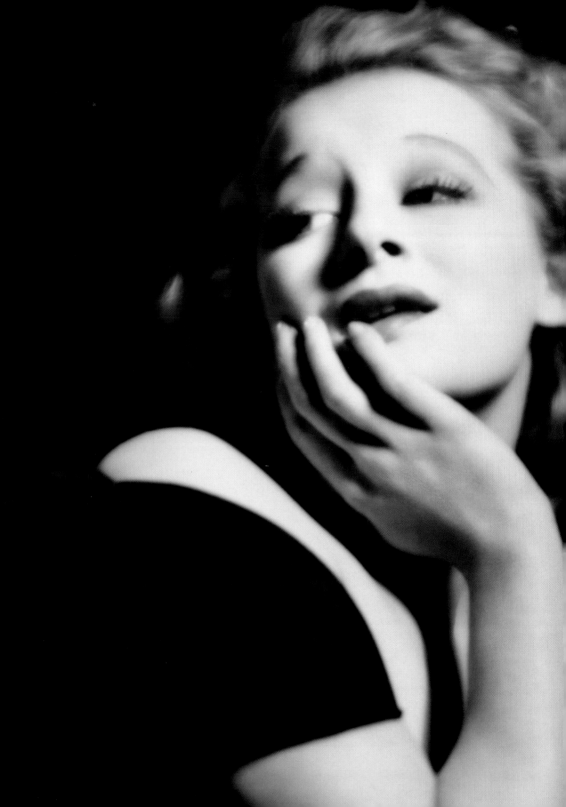

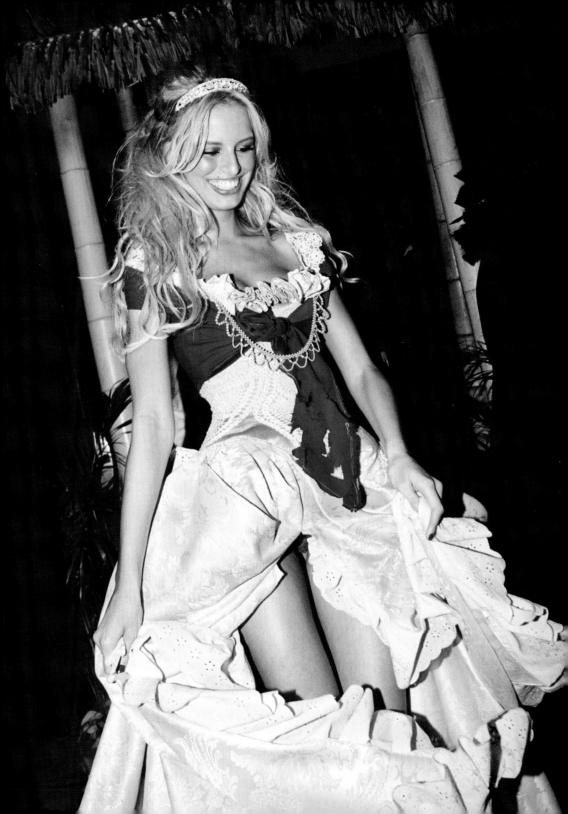

Moulin Rouge

1 oz passion fruit puree
or fresh passion fruit
1 oz grenadine
1 oz strawberry vodka
½ oz Moët & Chandon

MIX PUREE, GRENADINE,
AND STRAWBERRY VODKA
OVER ICE. TOSS ONCE AND
STRAIN INTO GLASS. TOP OFF
WITH CHAMPAGNE. GARNISH
WITH STRAWBERRIES.

Orzata

¾ oz Frangelico
¾ oz Amaretto
4 oz of steamed milk

SERVE IN A FOOTED
MUG. TOP OFF WITH

"One martini is alright, two is too many, three is not enough."

—James Thurber

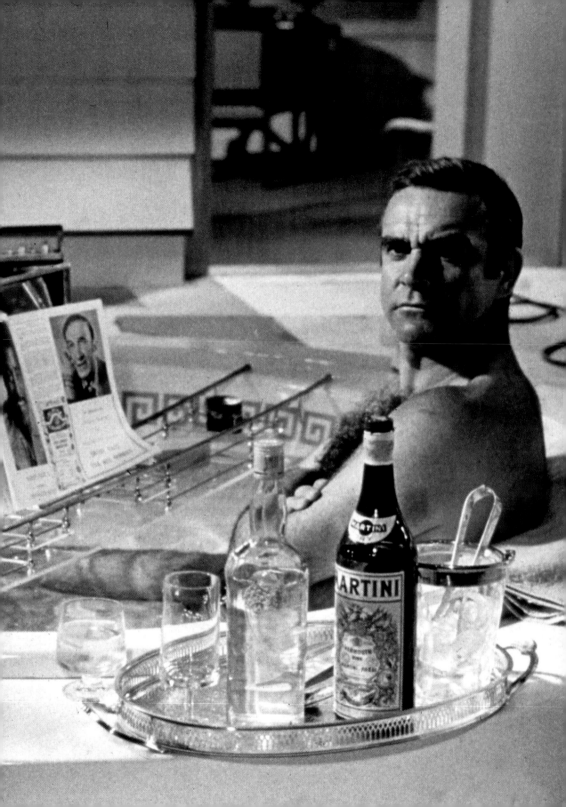

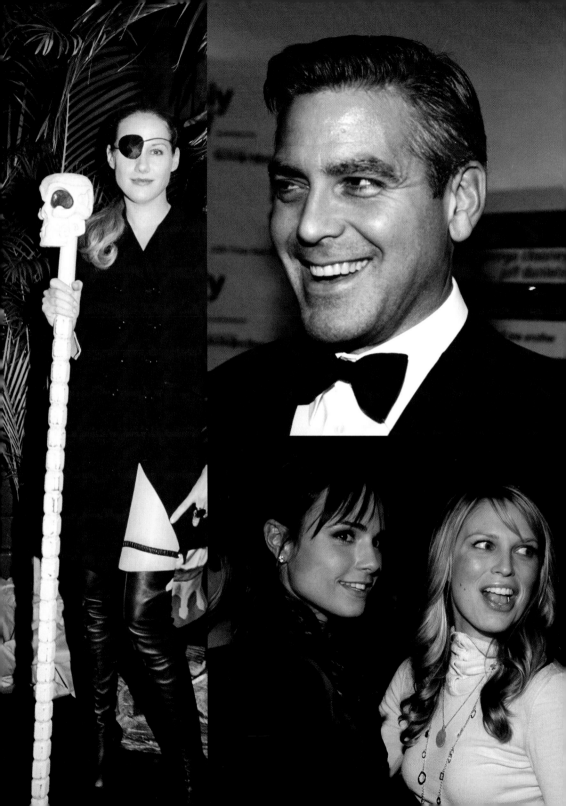

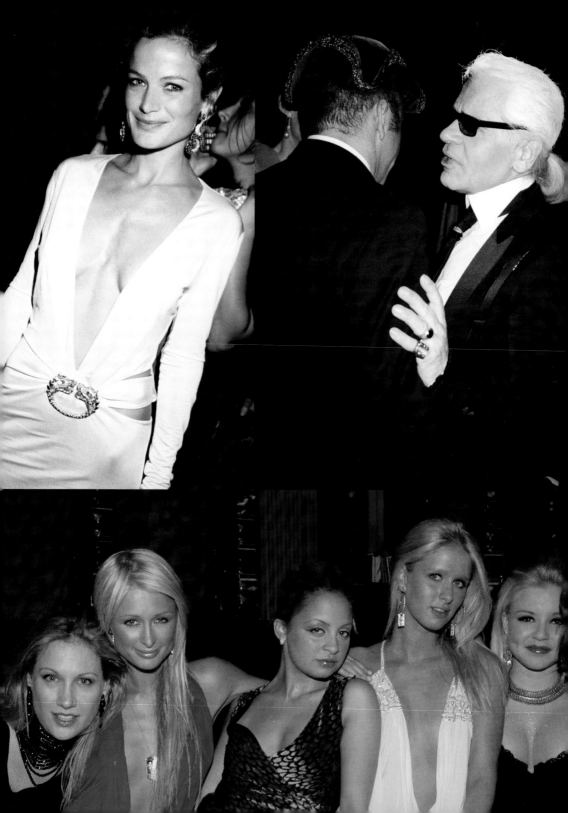

For the last few years, I've practically lived at Bungalow 8. I became its Rick, from Casablanca, *its Kitty from* Gunsmoke.

Summerhouse

1 ½ oz Ketel One vodka
¼ oz crème de peche
2 oz apricot puree

MIX INGREDIENTS OVER ICE. TOSS
ONCE AND POUR INTO A HIGHBALL
GLASS. TOP OFF WITH SODA.

"Always remember that I have taken more out of alcohol than alcohol has taken out of me."

—Winston Churchill

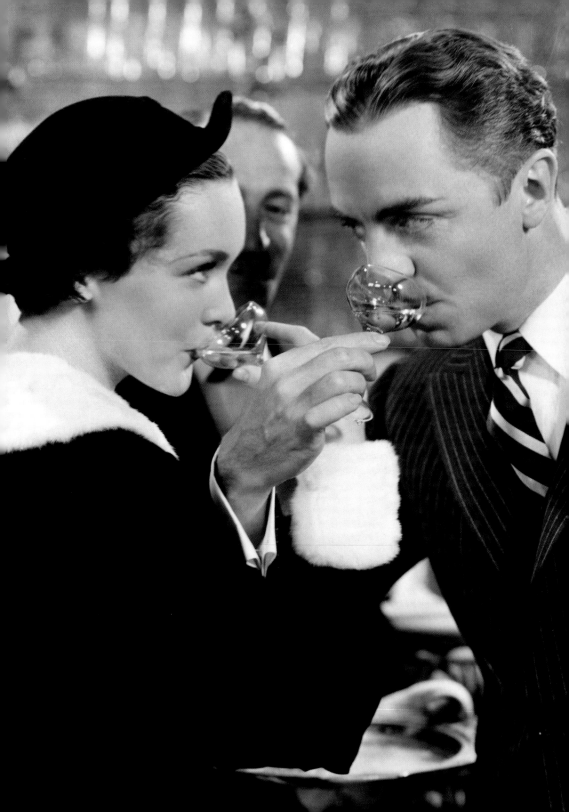

Cowboy Martini

2 ½ oz Ketel One vodka
½ oz simple syrup
½ oz lime juice
sprigs of mint

MUDDLE MINT WITH LIME JUICE.
ADD VODKA AND SYRUP. POUR OVER ICE.
SHAKE AND STRAIN INTO A MARTINI GLASS.
GARNISH WITH EXTRA MINT.

"What 'is' a cocktail dress? Something to spill cocktails on."

—William Powell & Jean Arthur

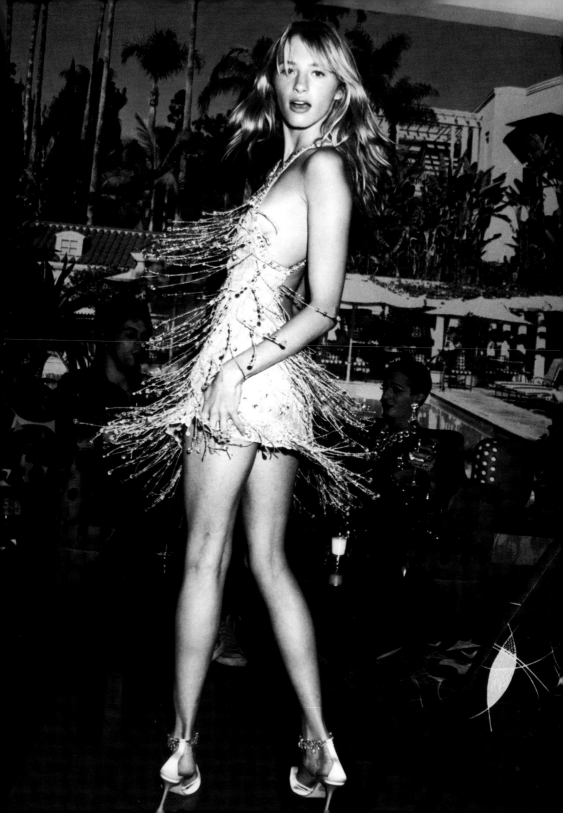

Blue Blood

1 ½ oz Ketel One vodka
2 oz blackberry puree
7-Up

MIX VODKA AND PUREE WITH
ICE. TOSS ONCE. POUR INTO A
HIGHBALL GLASS. TOP WITH 7-UP.
SERVE WITH LIME GARNISH.

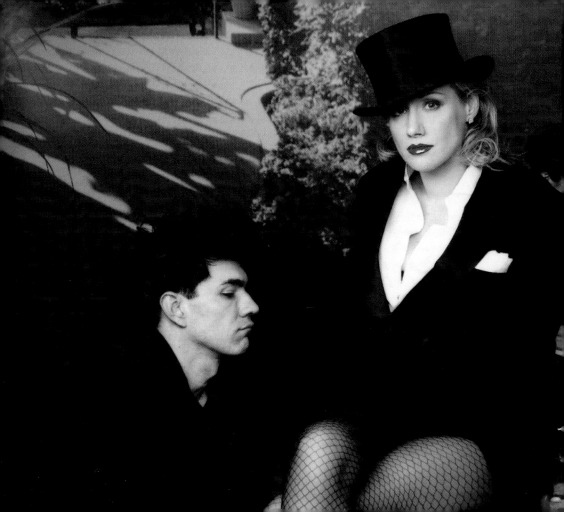

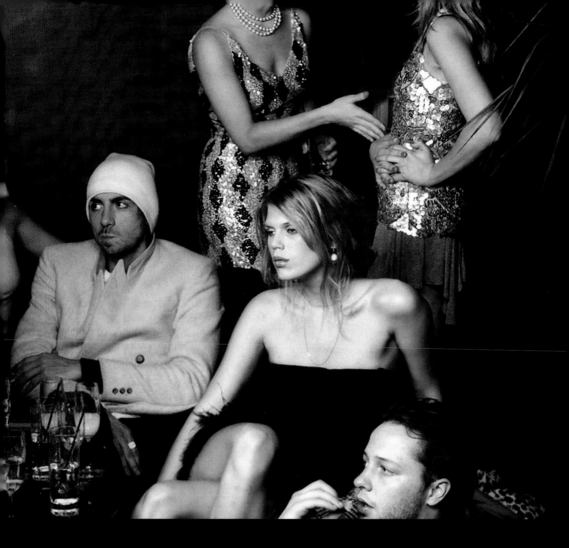

Brazilian Casting Couch

½ oz simple syrup
½ oz rum
1 oz champagne
3 lime wedges
2 tablespoons of brown sugar
5 sprigs of mint
touch of lime juice

MUDDLE LIMES, SUGARS, MINT AND JUICE.
ADD RUM AND ICE. SHAKE AND STRAIN INTO A
FLUTE GLASS. TOP OFF WITH CHAMPAGNE. GARNISH
WITH MINT.

Chanteuse

1 oz chilled Grey Goose vodka
splash of apple eau-de-vie
2 oz green apple puree
splash of champagne

STIR LIGHTLY WITH A STRAW.
TOP OFF WITH CHAMPAGNE.

Snowfall Martini

2 oz vanilla vodka
1 oz cream
½ oz simple syrup
1–2 slice vanilla bean

MUDDLE THE BEANS BEFORE
ADDING ALL THE INGREDIENTS
OVER ICE. SHAKE AND STRAIN
INTO A CHILLED, SUGAR-RIMMED
MARTINI GLASS.

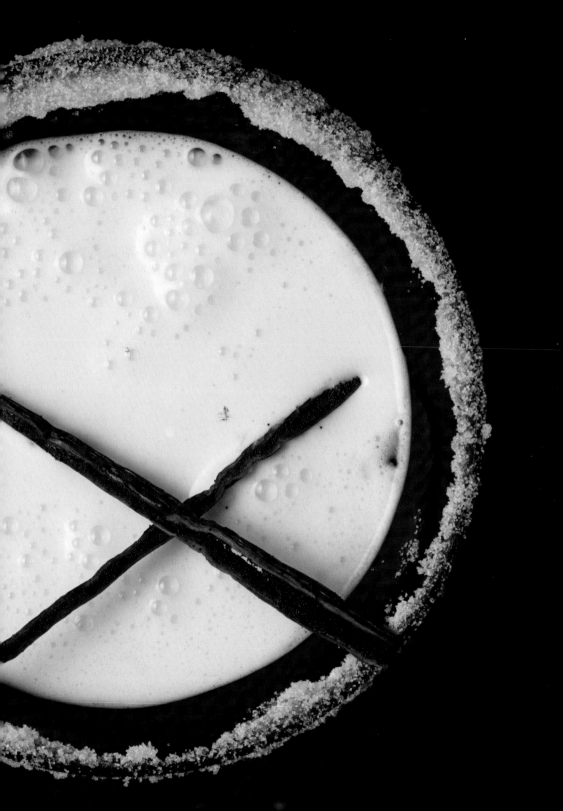

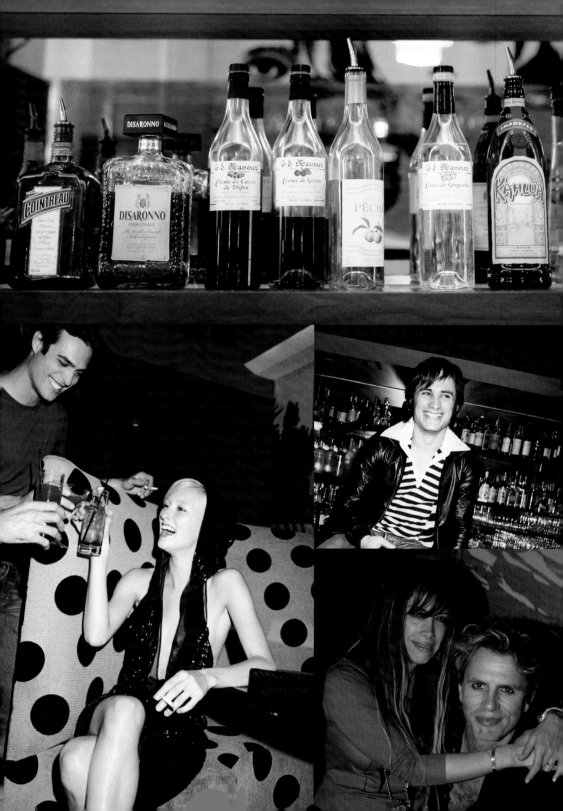

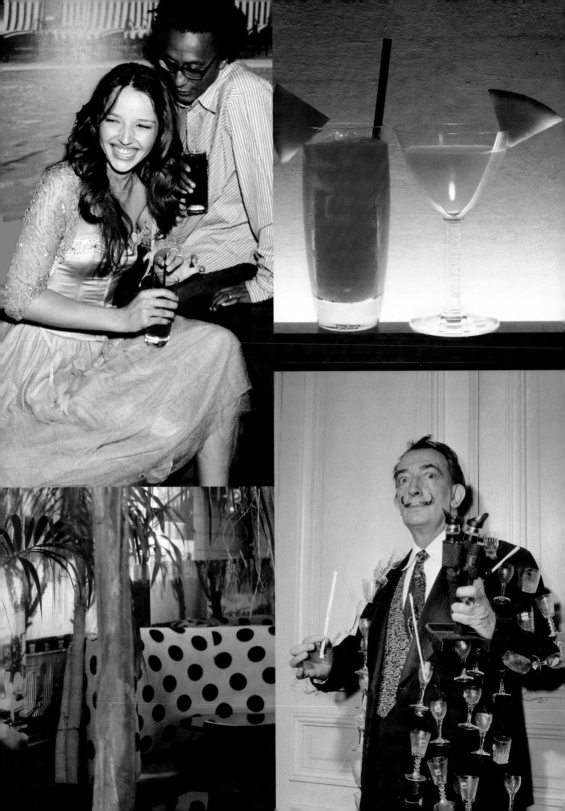

" Amy is New York's long-legged queen of the night... She could have held her own with Sinatra. "

—Kevin Spacey

The Hills

2 oz Malibu rum
1 ½ oz Midori
2–3 oz grapefruit juice
2–3 oz orange juice
2 tablespoons sugar
Moët & Chandon champagne

MIX JUICES, RUM, AND MIDORI OVER ICE. SHAKE
AND STRAIN INTO A CHILLED, SUGAR-RIMMED
MARTINI GLASS. TOP OFF WITH CHAMPAGNE.

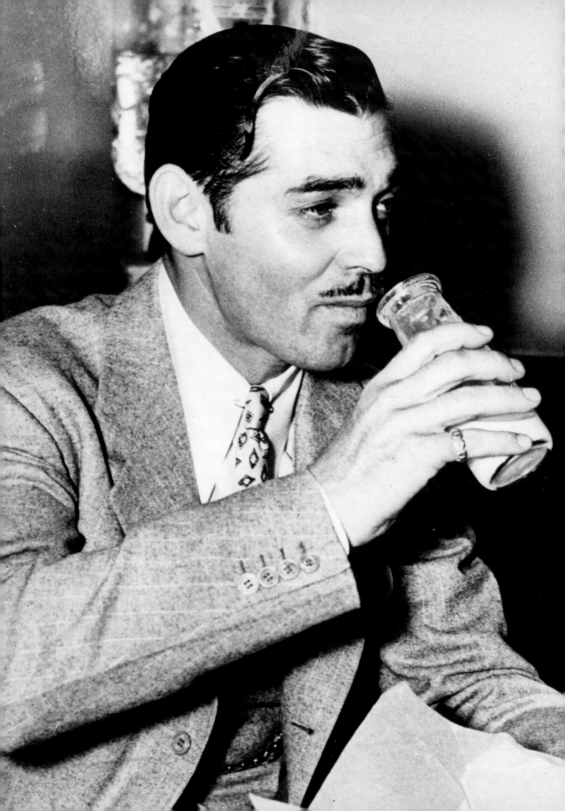

> **"Come on. Let's get something to eat. I'm thirsty."**
>
> —William Powell

Gentleman's Lemonade

2 oz Michter's Rye
½ oz fresh lemon juice
½ oz simple syrup

MIX INGREDIENTS OVER ICE. TOSS
ONCE. POUR INTO A HIGHBALL
GLASS. TOP OFF WITH SODA AND
GARNISH WITH LEMON WHEELS.

Cantaloupe Mojito

2 ½ oz light or dark rum
2 tablespoons of sugar
3 lime wedges
3–4 pieces of cantaloupe
5 sprigs of mint

MUDDLE SUGAR, LIMES,
AND MINT. ADD RUM AND
ICE. TOSS ONCE AND POUR
INTO GLASS. TOP OFF WITH CLUB
SODA. GARNISH WITH MELON.

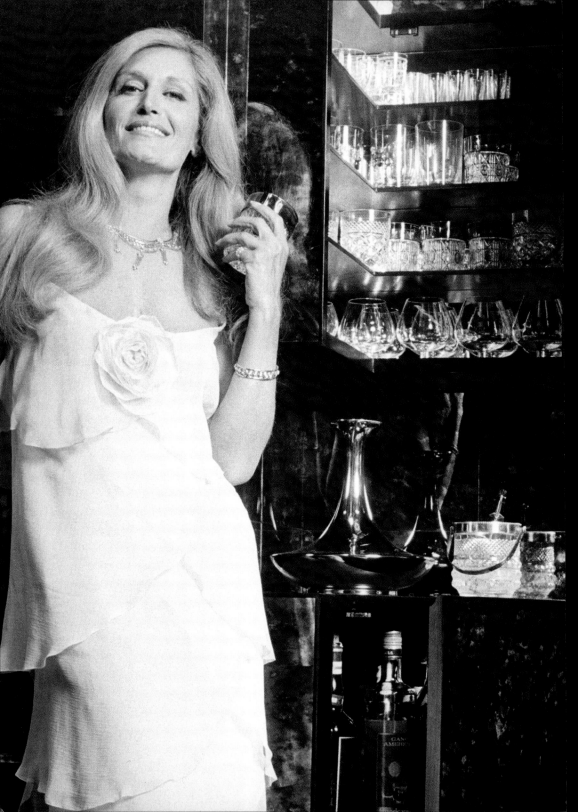

Valentino

1 ¼ oz chilled
raspberry vodka
½ oz Chambord
¾ oz lemon juice
¾ oz simple syrup

MIX ALL INGREDIENTS. TOP OFF
WITH STRAWBERRY GARNISH.

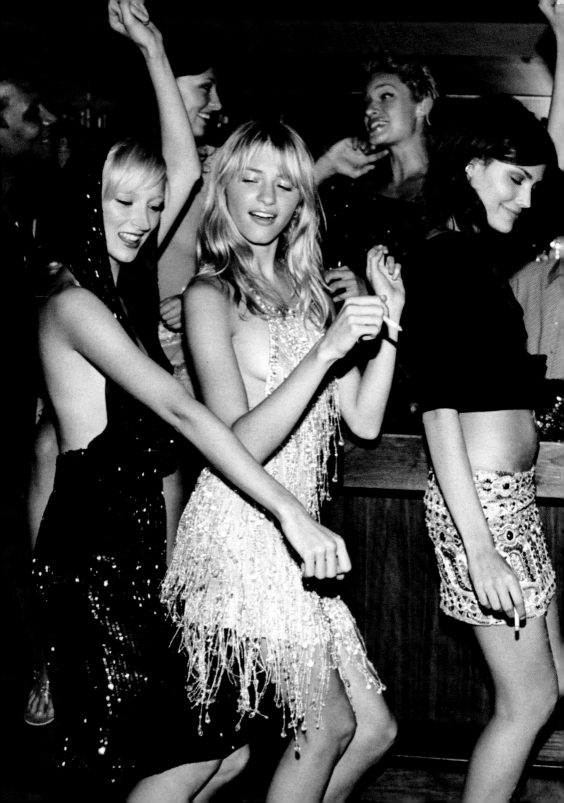

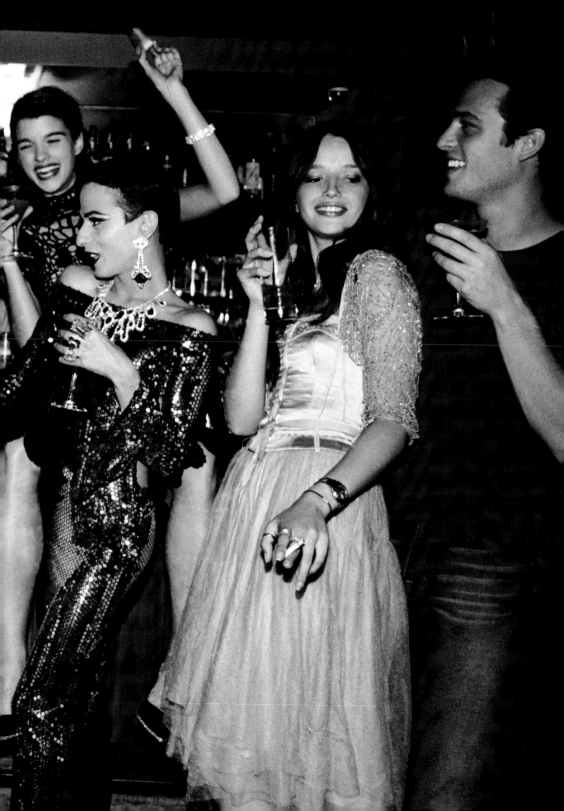

Apple Bette

2 oz Ketel One vodka
1 ½ oz apple eau-de-vie
1 ½ oz pêche eau-de-vie
splash of apple puree

MIX ALL INGREDIENTS OVER ICE.
SHAKE AND STRAIN INTO A
CHILLED MARTINI GLASS.

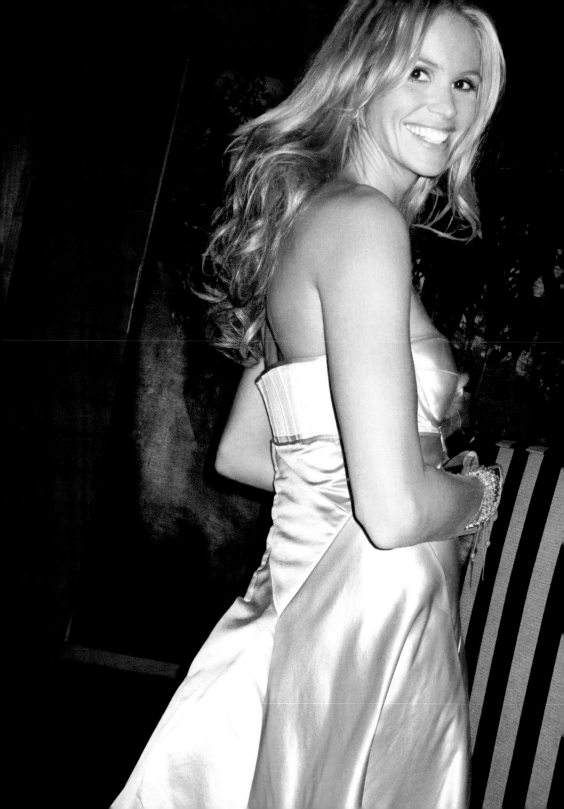

"Look, Sweetheart, I can drink you under any goddamn table you want, so don't you worry about me."

—*Elizabeth Taylor,*
Who's Afraid of Virginia Woolf

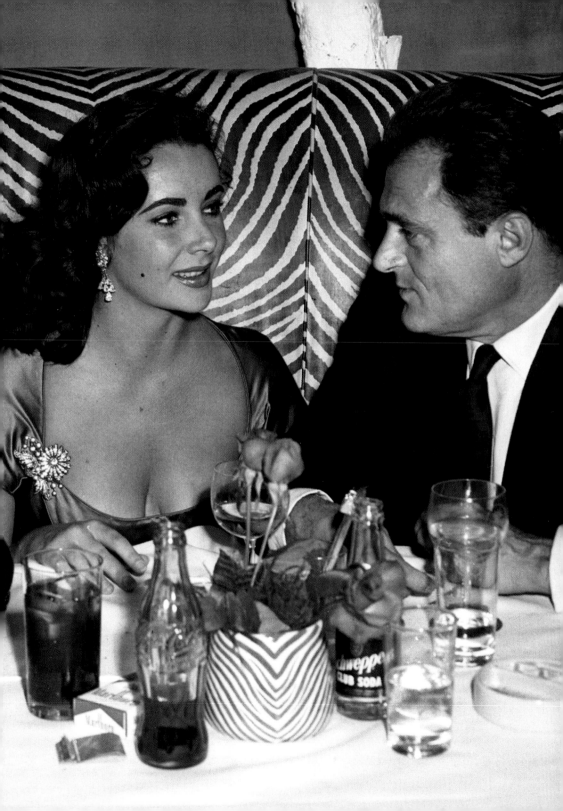

Cherry Julep

3 lime wedges
4 fresh cherries
2 oz Grey Goose vodka
splash of grenadine

MUDDLE CHERRIES, LIMES, AND GRENADINE. ADD VODKA AND ICE. SHAKE AND POUR INTO GLASS. TOP OFF WITH SODA.

Cosmonaut

2 oz of citrus vodka
½ oz Cointreau
splash of fresh lime juice
splash of Rose's lime juice
splash of white
cranberry juice

MIX INGREDIENTS OVER ICE. SHAKE AND STRAIN INTO A CHILLED MARTINI GLASS.

DURAN DURAN

JOHN TAYLOR • ROGER TAYLOR • ANDY TAYLOR
SIMON LEBON • NICK RHODES

BAND ONLY

Brass Button

1 oz Beefeater gin
2 oz orange juice
splash of Grand Marnier
Moët & Chandon
champagne

MIX INGREDIENTS OVER
ICE. SHAKE AND STRAIN
INTO A GLASS. TOP OFF
WITH CHAMPAGNE.

Bette Bellini

1 oz orange vodka
2 oz strawberry puree
splash of simple syrup
Moët & Chandon champagne

MIX VODKA, PUREE, AND SYRUP IN A
FLUTE. STIR LIGHTLY WITH A STRAW.
TOP OFF WITH CHAMPAGNE.

Starlett

1 ½ oz Grey Goose vodka
½ oz ginger liqueur
¼ oz lime juice
¼ oz simple syrup
1 barspoon star fruit puree

MIX INGREDIENTS OVER ICE.
TOSS ONCE AND POUR INTO A
HIGHBALL GLASS. TOP OFF WITH
CLUB SODA. GARNISH WITH SLICES
OF STAR FRUIT.

Espresso
Martini

1 ½ oz chilled espresso
½ oz Kahlua
1 ¾ oz Ketel One vodka
dash of Sambuca

MIX ESPRESSO, KAHLUA, AND
VODKA OVER ICE. SHAKE AND
STRAIN INTO A CHILLED MARTINI
GLASS. TOP OFF WITH DASH OF
SAMBUCA. GARNISH WITH THREE
COFFEE BEANS.

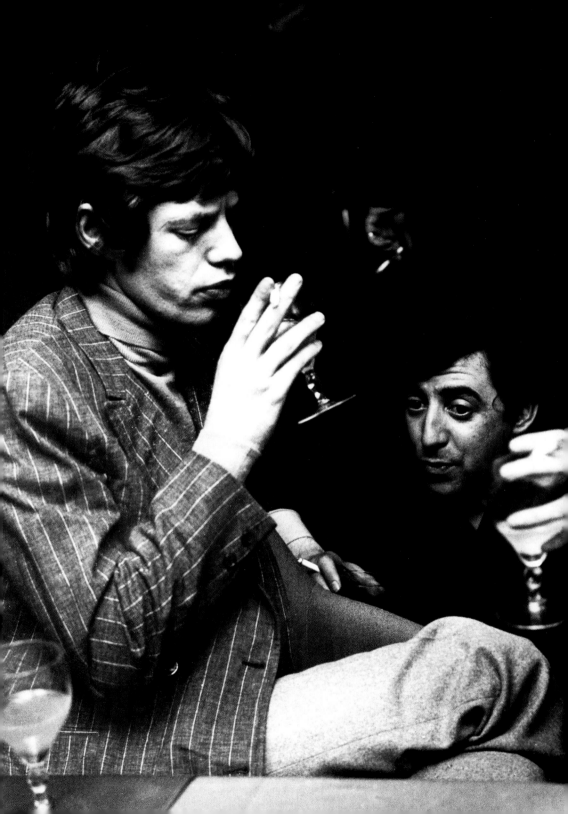

**" Work
is the curse
of the drinking
class. "**

—Oscar Wilde

Watermelon Cooler *Vodka Champagne*

66 *Always have rhythm in your shaking. A Manhattan you always shake to foxtrot time, a Bronx to two-step time, a dry martini*

Passion Peach

1 oz passion fruit puree
1 oz peach puree
½ oz peach schnapps
1¾ oz vodka
2 tablespoons of sugar

MIX INGREDIENTS OVER ICE.
SHAKE AND STRAIN INTO A
CHILLED MARTINI GLASS.

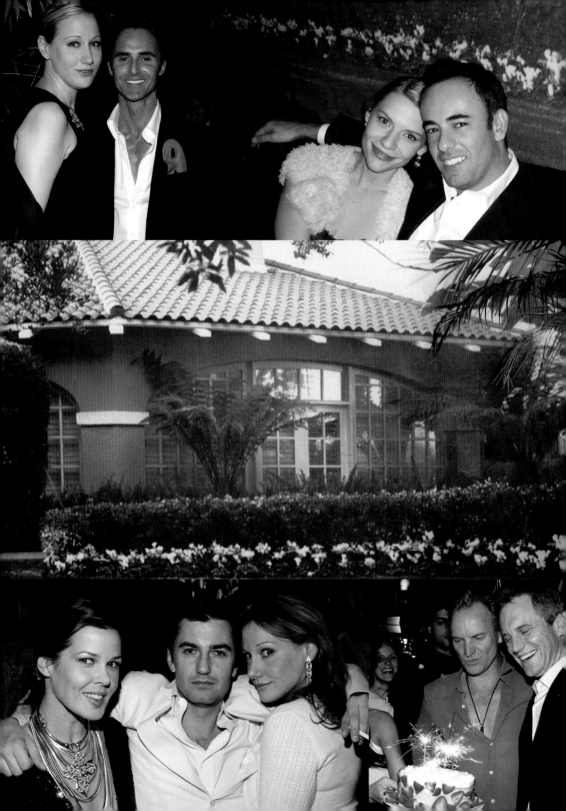

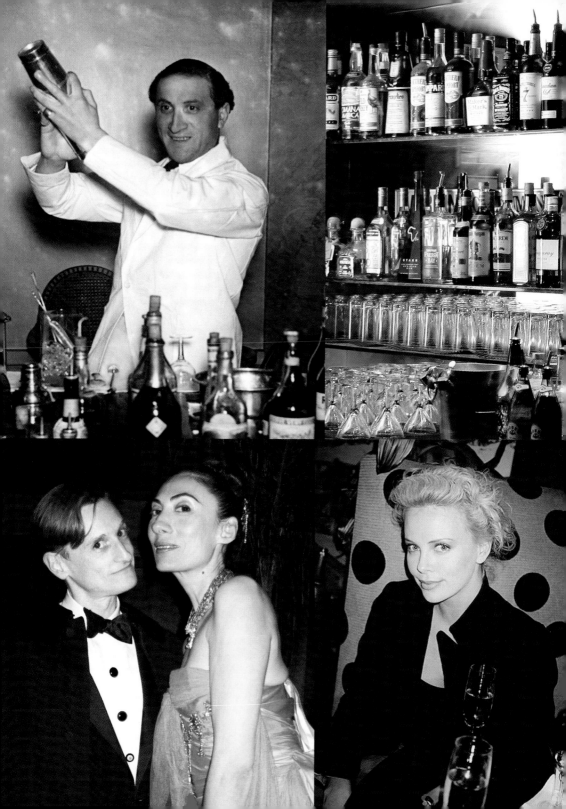

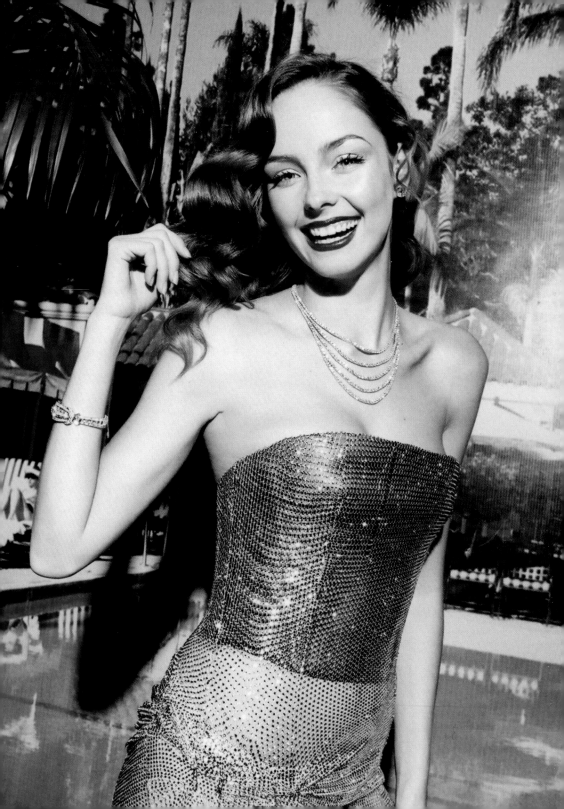

COCKTAILS

Amy Sacco © Annie Leibovitz/Contact Press Images.

Clockwise: © Kobal Collection; Mural by Lucas Michael and Jeremy Blake at Bungalow 8 © Benoit Pailley; photo © Roxanne Lowit; Ruby Diamond serving cocktails, November 11, 1966 © Bettmann/Corbis; Plum Sykes © Patrick McMullan; Bar photo © Benoit Pailley; Jodie Kidd and Zani Guggelman © Patrick McMullan; Cocktails © Getty Images.

Marilyn Monroe © Rue des Archives; Saccotini, photo © Kanji Ishii.

Eve's Plum, photo © Kanji Ishii.

Bardot Martini, photo © Benoit Pailley.

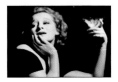

Actress Greta Nissen © John Springer Collection/Corbis.

Opposite: Delphine Dijon © Roxanne Lowit.

Karolina Kurkova © Roxanne Lowit; Moulin Rouge, photo © Kanji Ishii.

Photo © Benoit Pailley; Orzata, photo © Kanji Ishii.

Sean Connery in *Diamonds Are Forever*, 1971.

Clockwise: Amy Sacco © Roxanne Lowit; George Clooney © Patrick McMullan; Caroline Murphy © Roxanne Lowit; Karl Lagerfeld © Roxanne Lowit; Amy Sacco, Paris Hilton, Nicole Richie, Nicky Hilton, Casey Johnson, and Lauren Bush © Patrick McMullan; Jordana Brewster and S Foster © Patrick McMullan.

Summerhouse, photo © Kanji Ishii.

Maureen O'Sullivan and William Powell in *The Thin Man* © John Springer Collection/Corbis.

Cowboy Martini, photo © Benoit Pailley.

Sarah Ziff © Roxanne Lowit.

Blue Blood, photo © Benoit Pailley.

Amy Sacco © Annie Leibovitz/Contact Press Images.

Snowfall Martini, photo © Kanji Ishii.

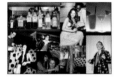

Bar, photo © Benoit Pailley; Renata © Roxanne Lowit; Cocktail photo © Kanji Ishii; Salvador Dalí wearing jacket covered with drinking glasses in 1964 © Bettmann/Corbis; Bungalow 8, photo © Benoit Pailley; Gela and John Taylor © Patrick McMullan; Lisa Forstberg © Roxanne Lowit; Gael Garcia Benal © Roxanne Lowit.

The Hills, photo © Benoit Pailley.

Clark Gable in 1937 © Bettmann/Corbis.

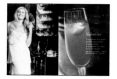

Bungalow 8, photo © Benoit Pailley; Cantaloupe Mojito, photo © Benoit Pailley.

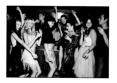

Singer Dalida at her home in Montmartre, Paris in 1973 © Pierre Vauthey/Corbis Sygma; Valentino, photo © Benoit Pailley.

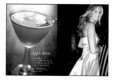

A party scene at Bungalow 8 © Roxanne Lowit.

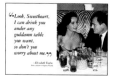

Apple Bette, photo © Kanji Ishii; Elle Mcpherson © Roxanne Lowitt.

Elizabeth Taylor and Mike Todd in 1956 © Bettmann/Corbis.

Detail from "Riot" by Richard Phillips at Bette © Benoit Pailley; Audrey Hepburn © Kobal Collection; Brass Button, photo © Benoit Pailley; Yvonne Force Villeral © Patrick McMullan; Duran Duran table, photo © Patrick McMullan; Photo © Benoit Pailley; Detail from "Riot" by Richard Phillips at Bette © Benoit Pailley.

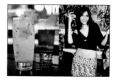

Starlett, photo © Kanji Ishii; Luciana Curtis © Roxanne Lowit.

Espresso Martini, photo © Kanji Ishii.

Mick Jagger at a cocktail party in the restaurant bar at the General Post Office Tower, London, 1966 © Hulton-Deutsch Collection/Corbis.

Bette Restaurant bar, photo © Benoit Pailley.

Passion Peach, photo © Benoit Pailley.

Amy Sacco and Anthony Todd © Patrick McMullan; Claire Danes and Francisco Costa © Roxanne Lowit; A barman at Hector's Devonshire Restaurant, London in 1930 © Sasha/Getty Images; Bungalow 8 © Benoit Pailley; Hamish Bowles and Anh Duong © Roxanne Lowit; Sting and John Sykes © Patrick McMullan; Mary Alice Stephenson, Euan Rellie, and Amy Sacco © Patrick McMullan; Charlize Theron © Roxanne Lowit.

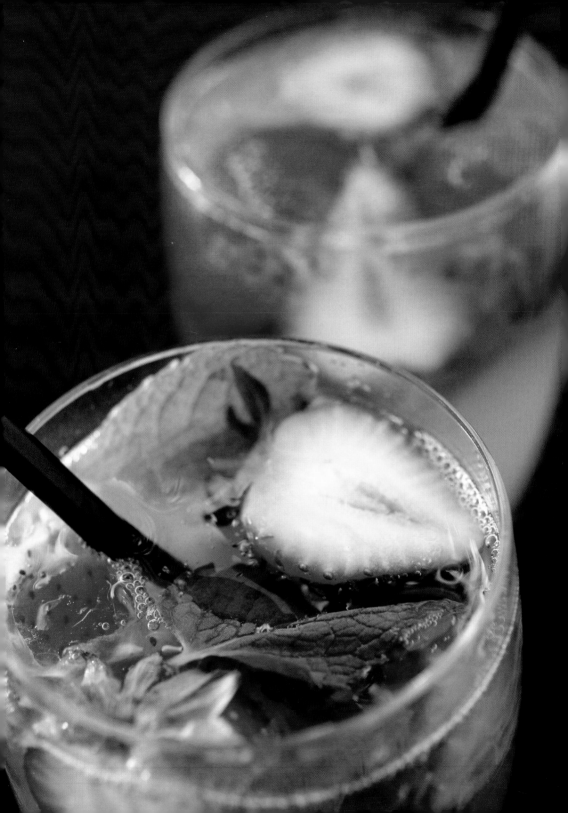

The author would like to thank:
Yvonne Force Villareal; Nadine Johnson Public Relations and all the staff of Bungalow 8 and Bette Restaurant; Martine and Prosper Assouline; LALIQUE for Glassware; Annie Leibovitz; Roxanne Lowit; Patrick McMullen; Collette Morris; Benoît Pailley; Rob Haskell; Kanji Ishii; Esther Kremer; Richard Phillips; Ray Pirkle; Diana and Rafael Viñoly.

Cocktail photo © Benoît Pailley.